Act

Without

Expectation

-Lao Tzu

Travis Harrison
Instagram: travis.harrison_

Cooper Dowd
Instagram: aleksandrdowd

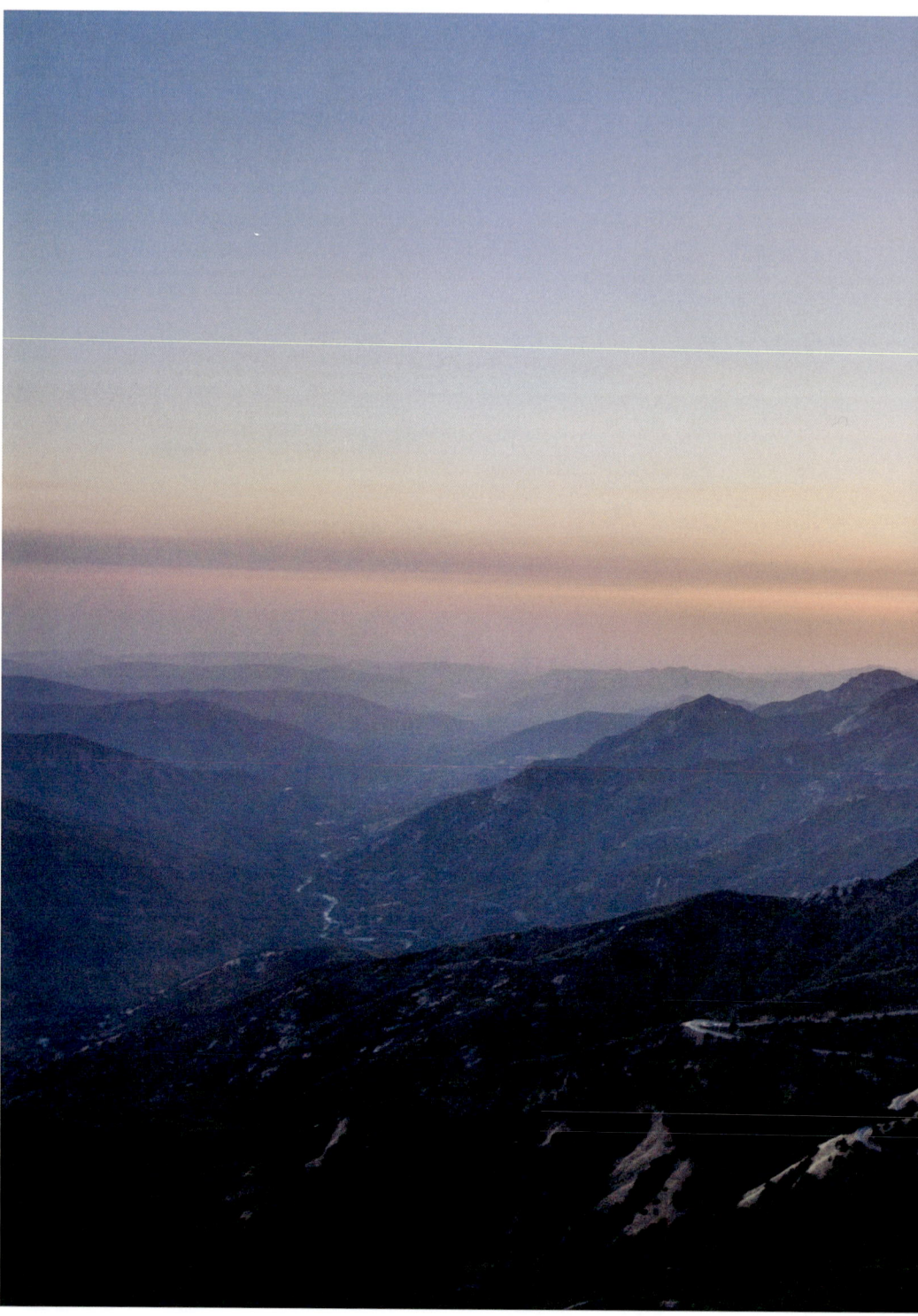

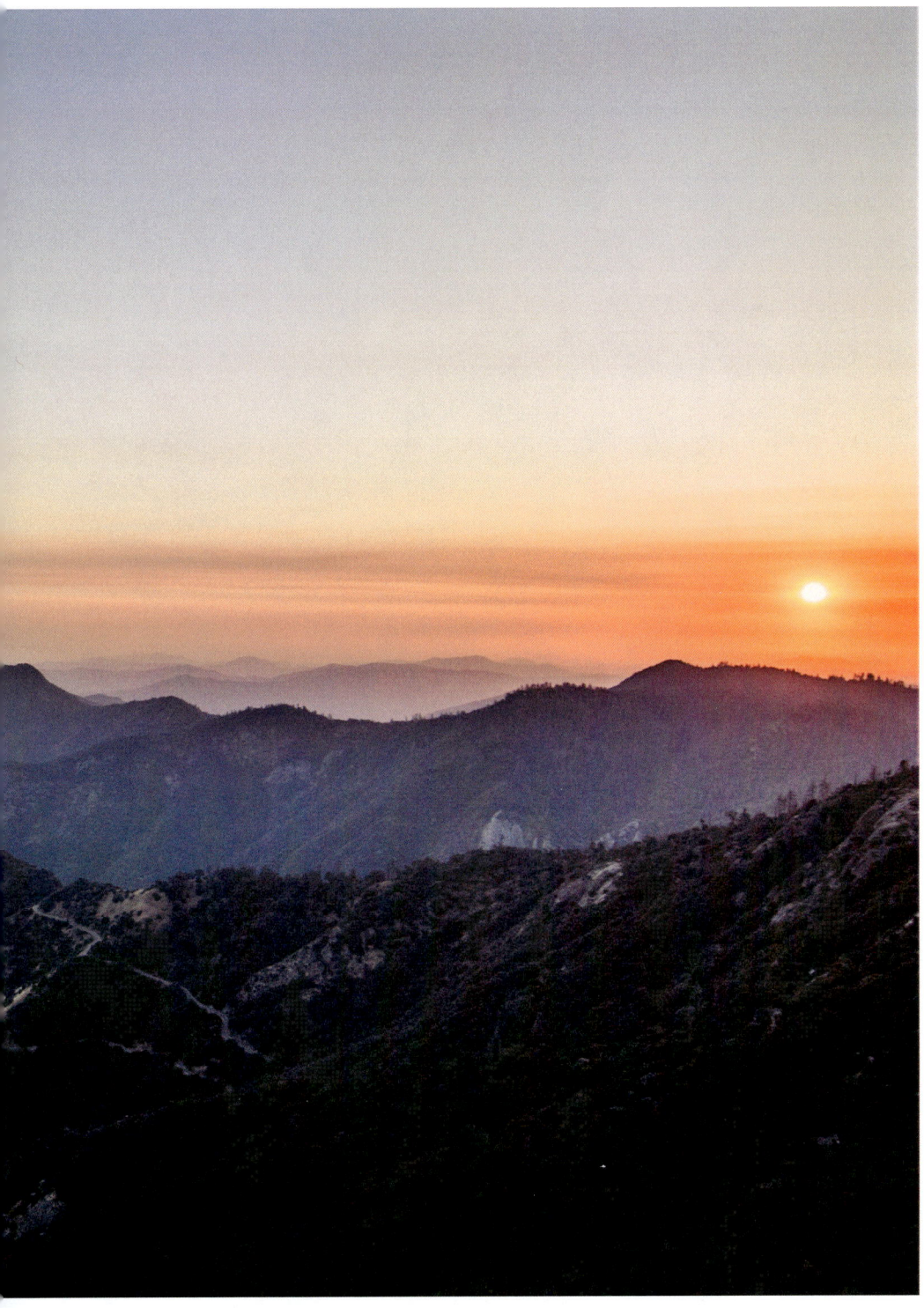

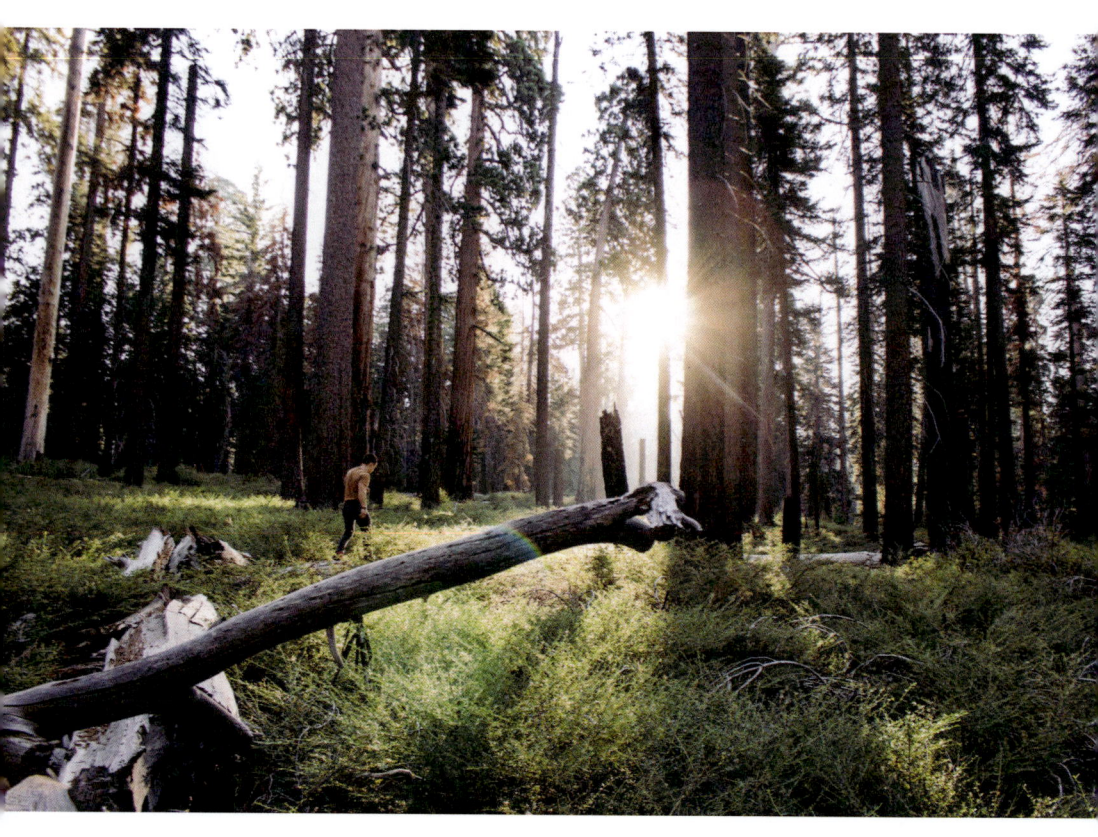

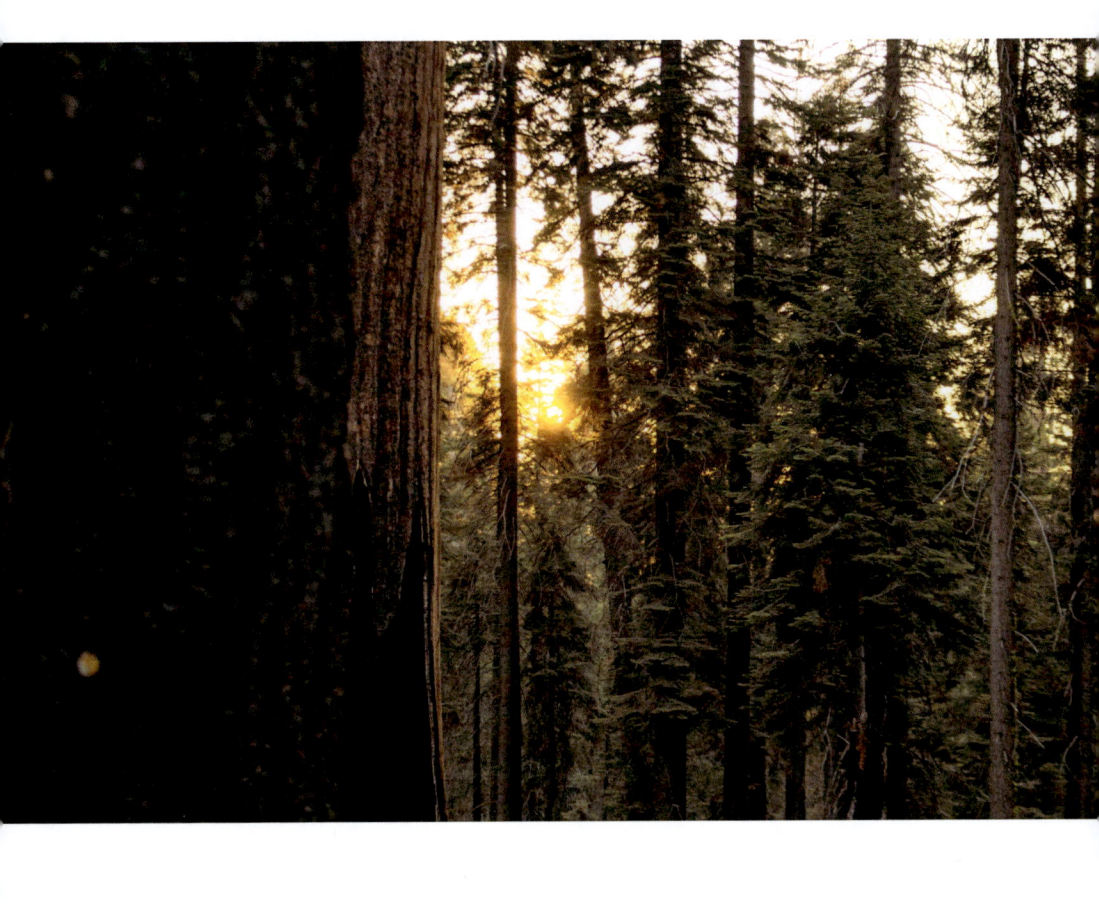

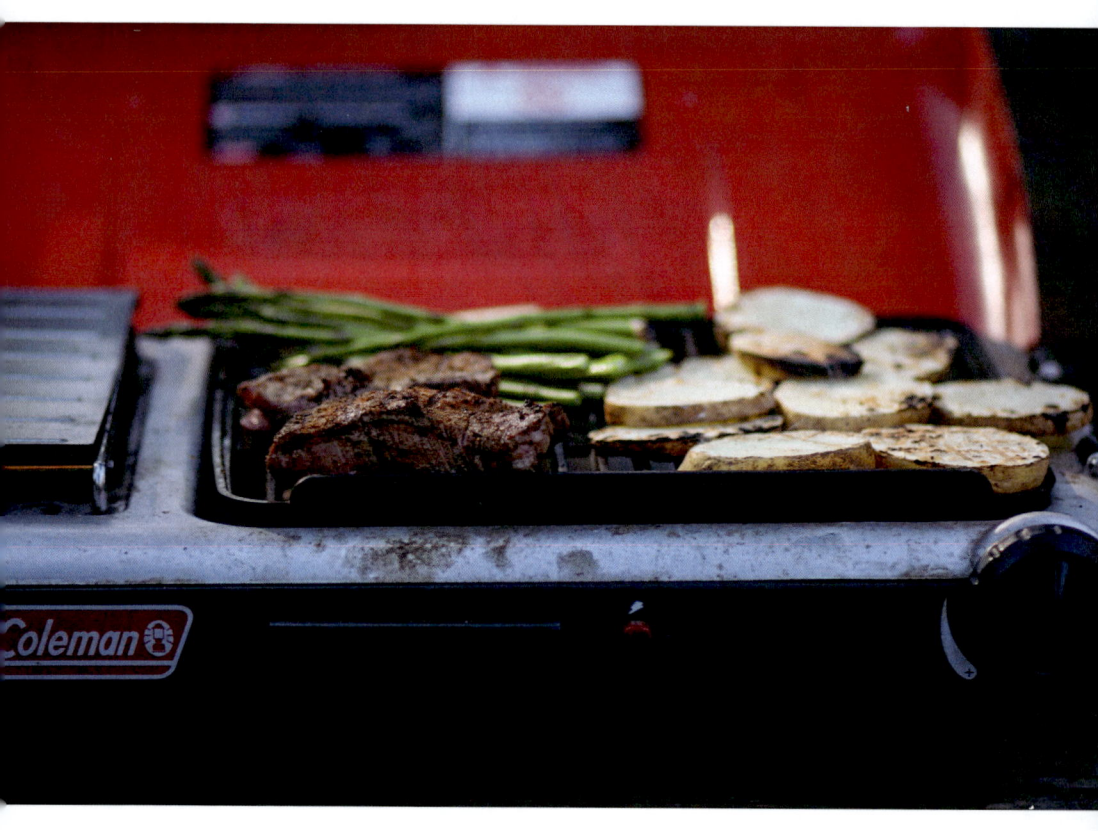

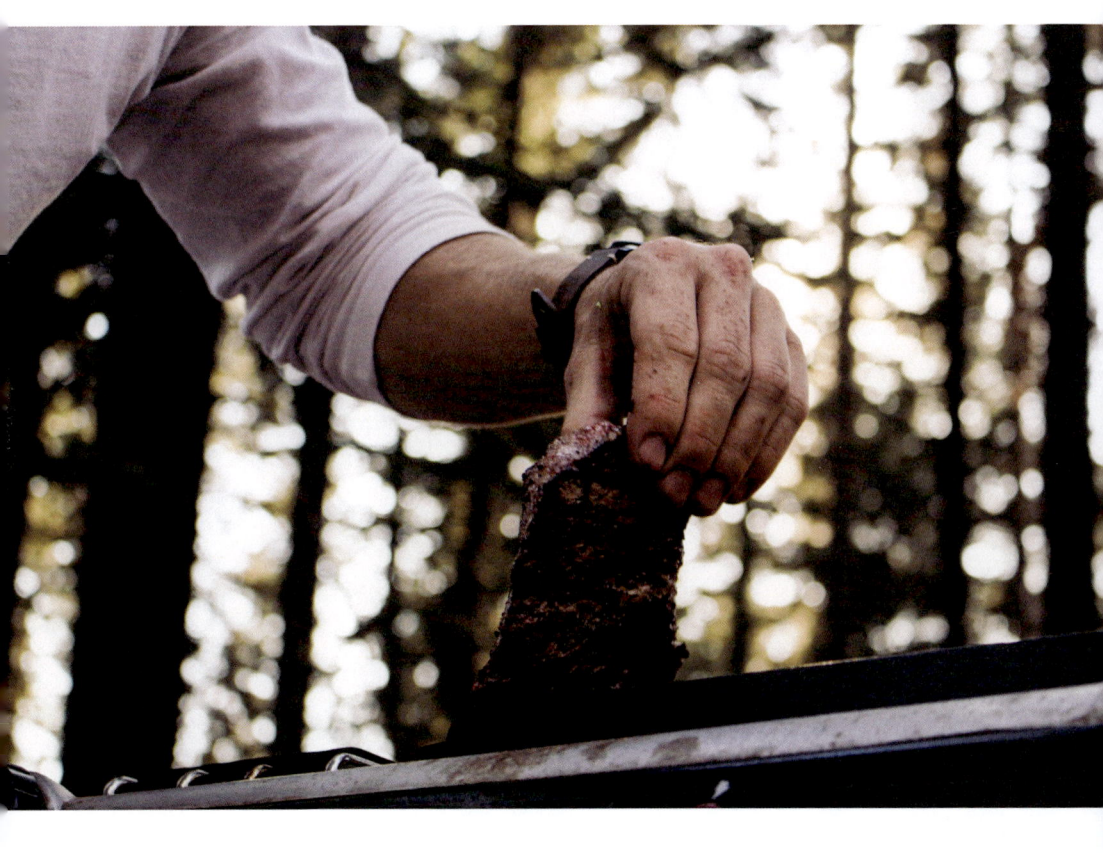

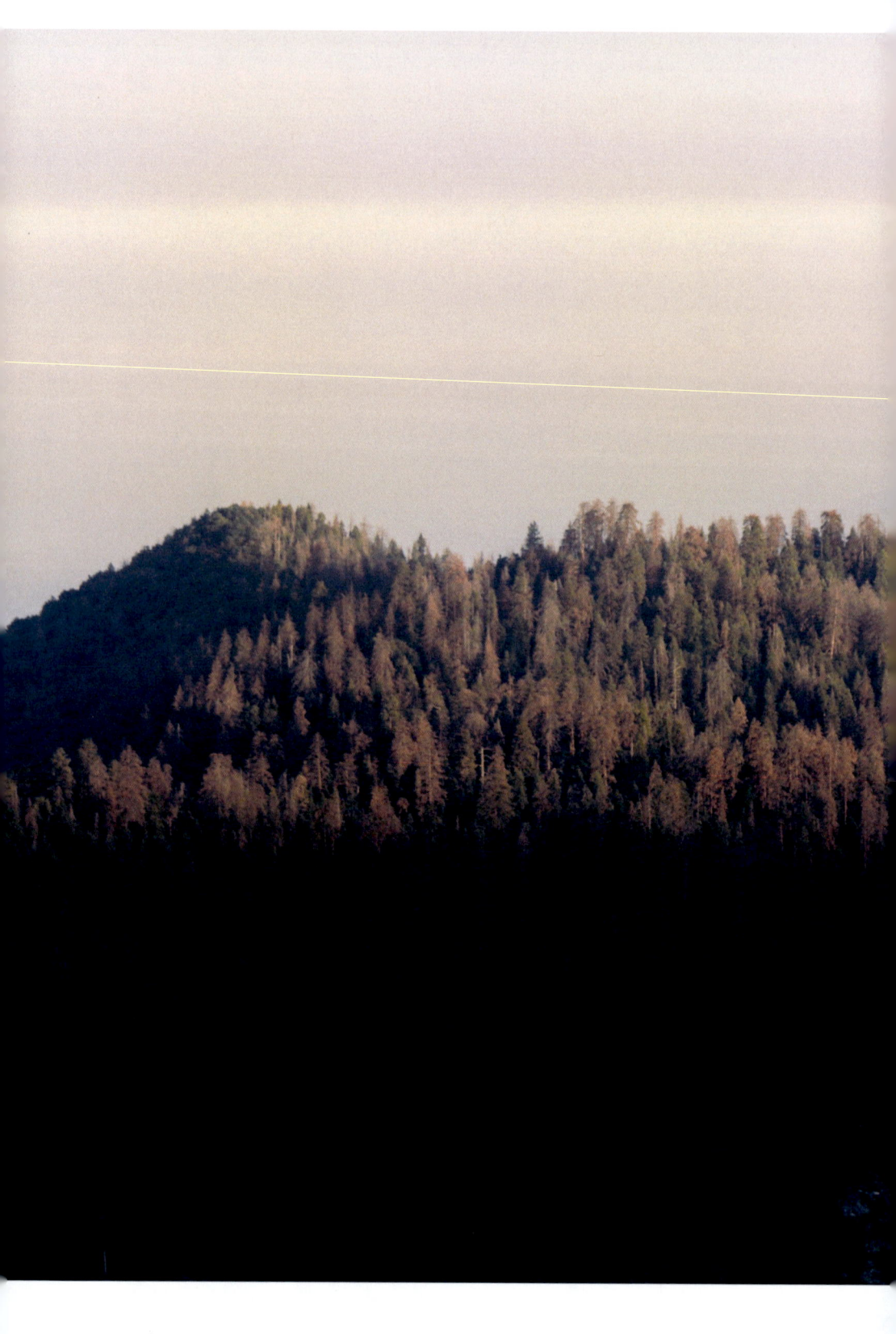

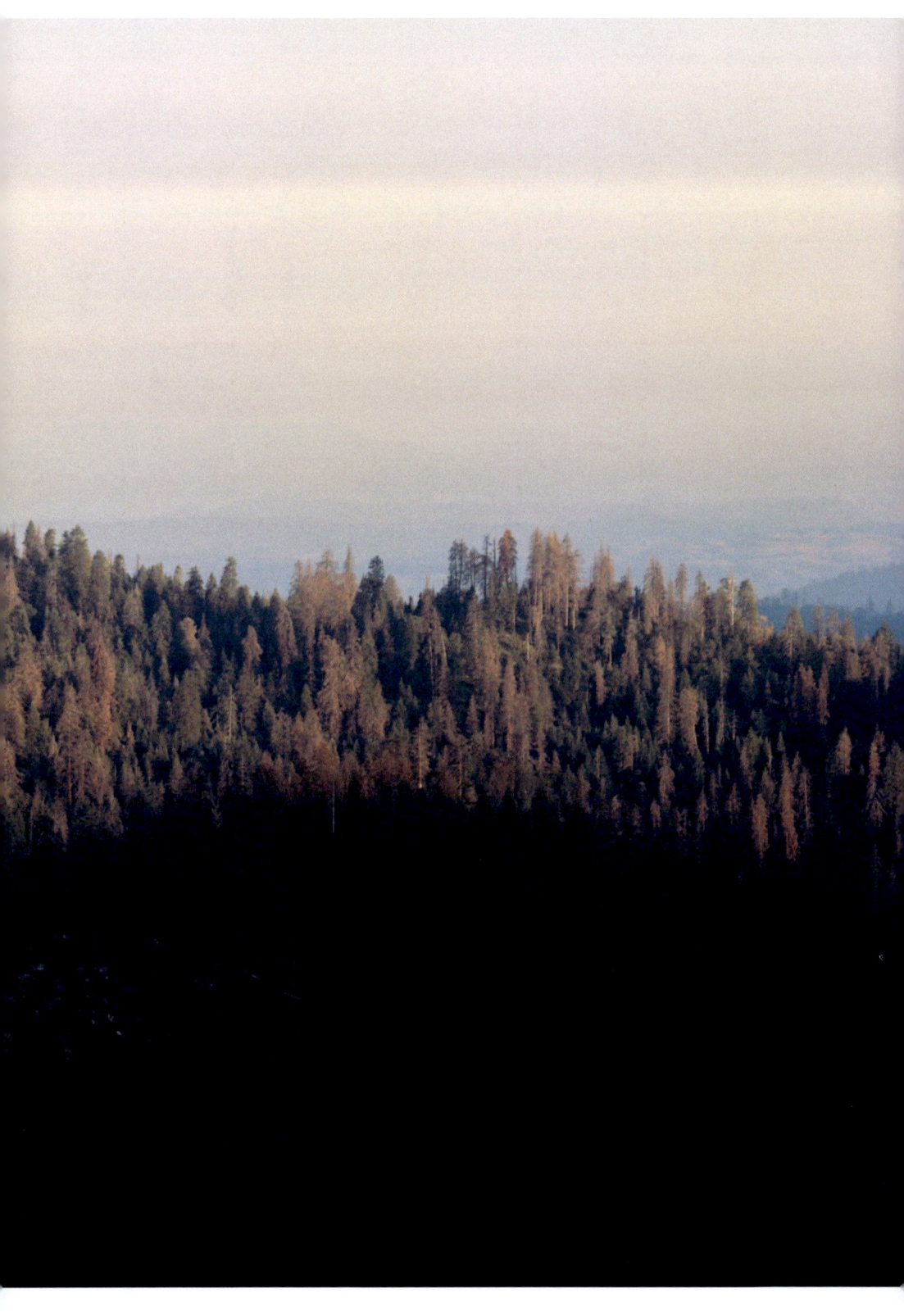

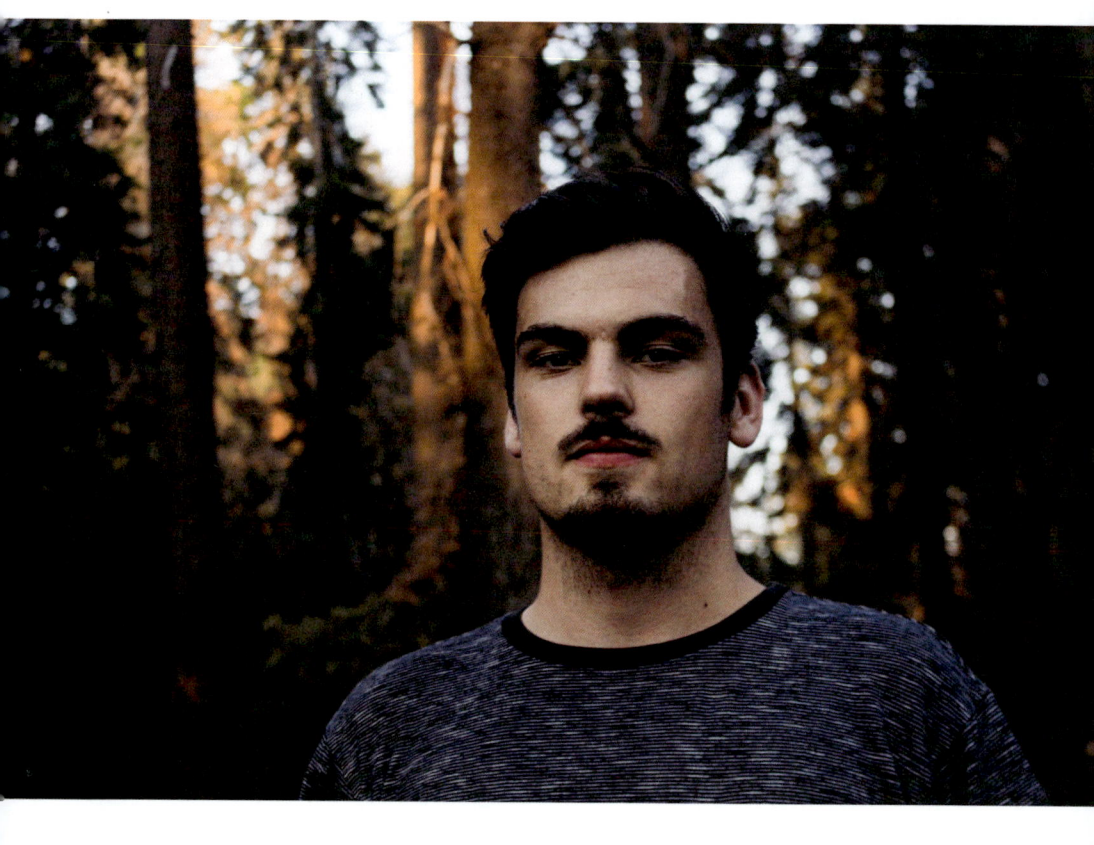

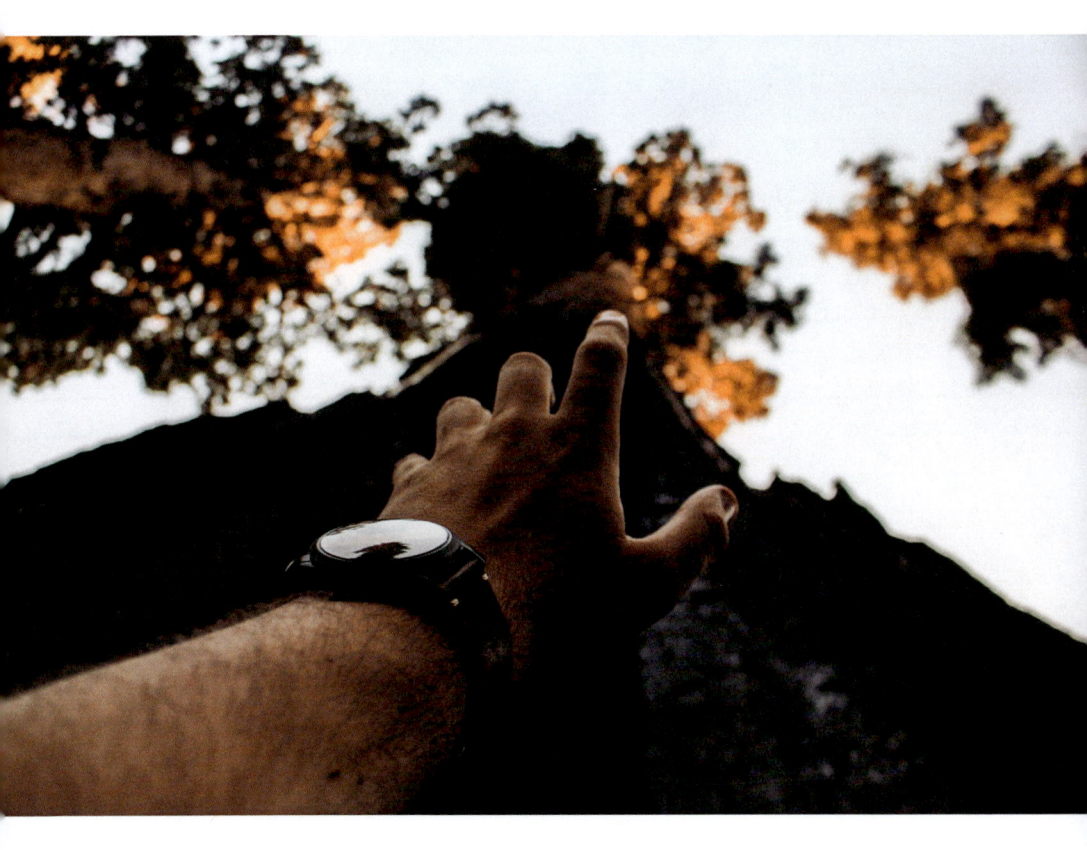

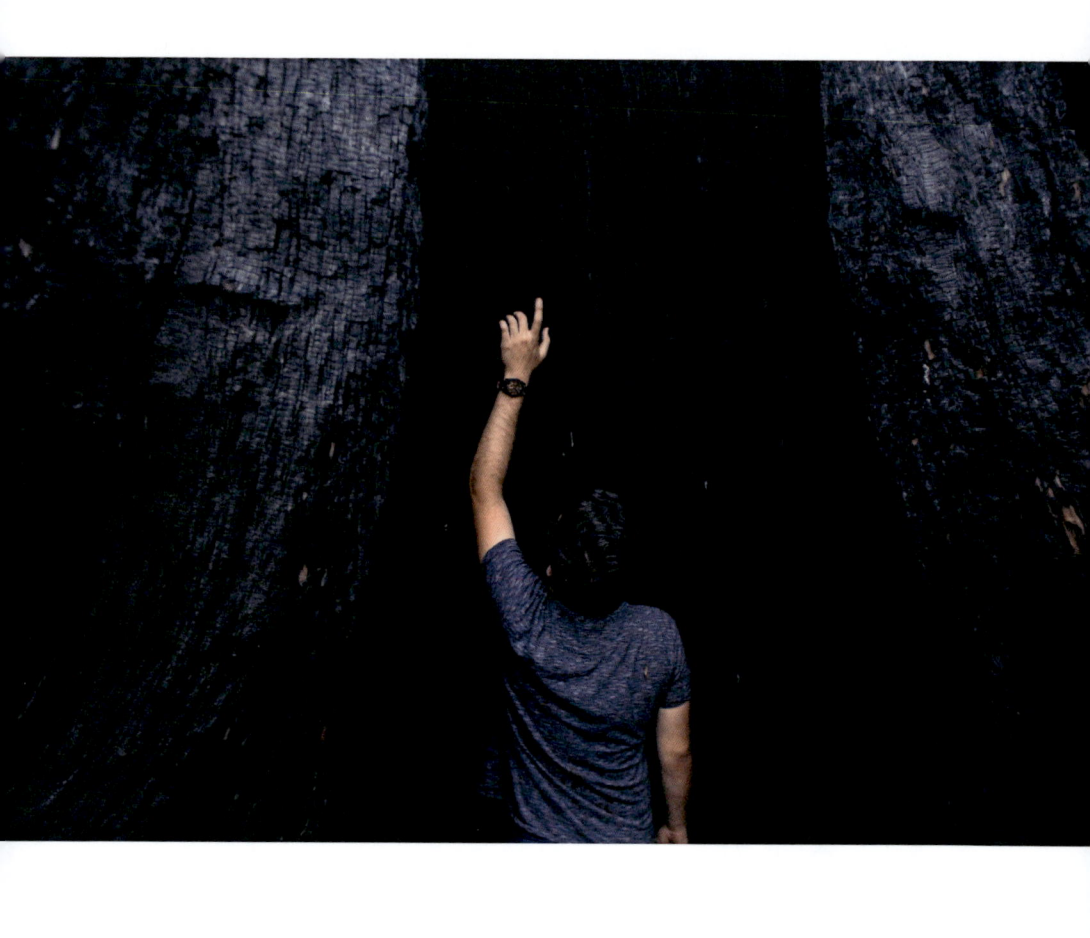

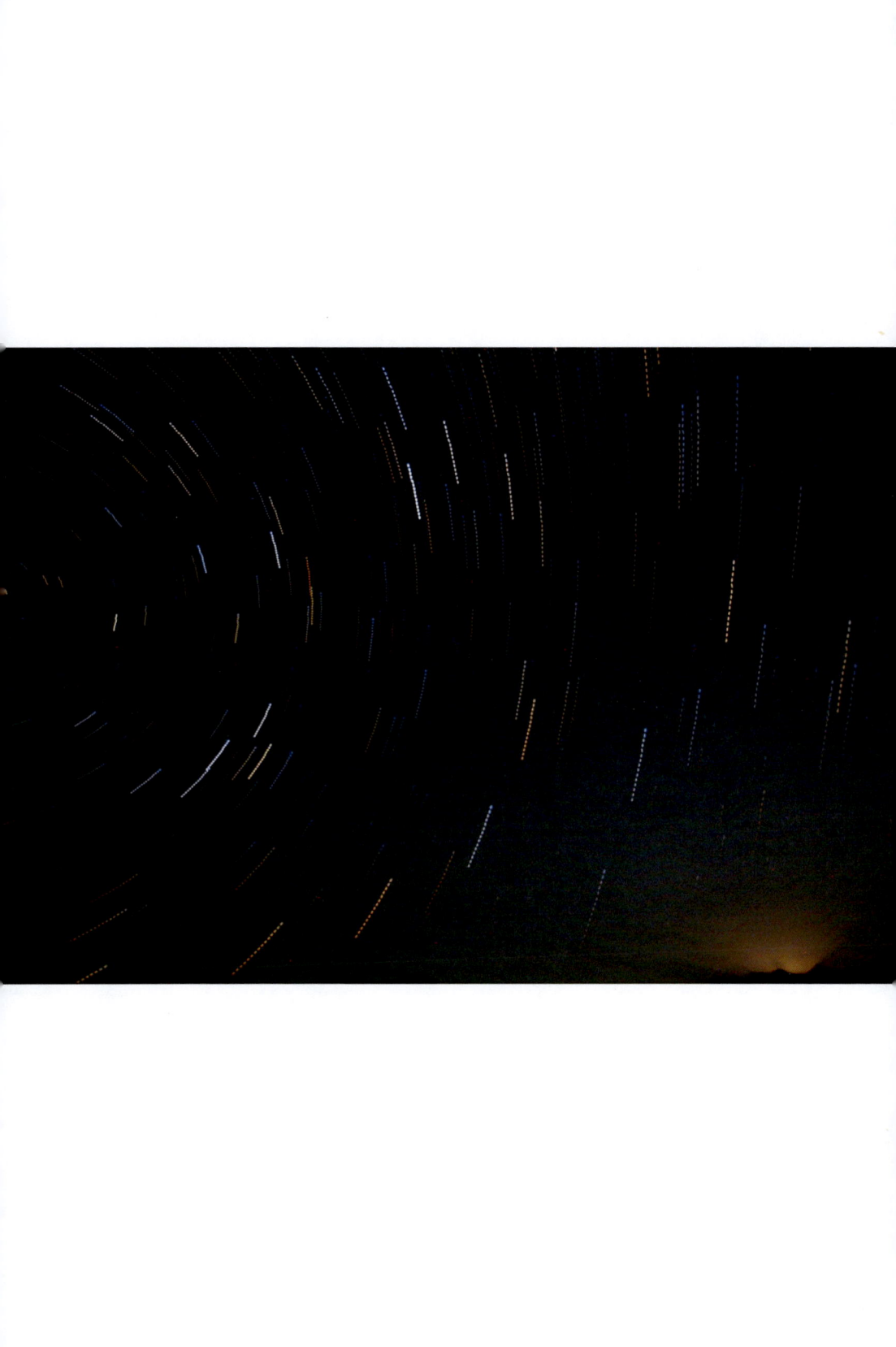

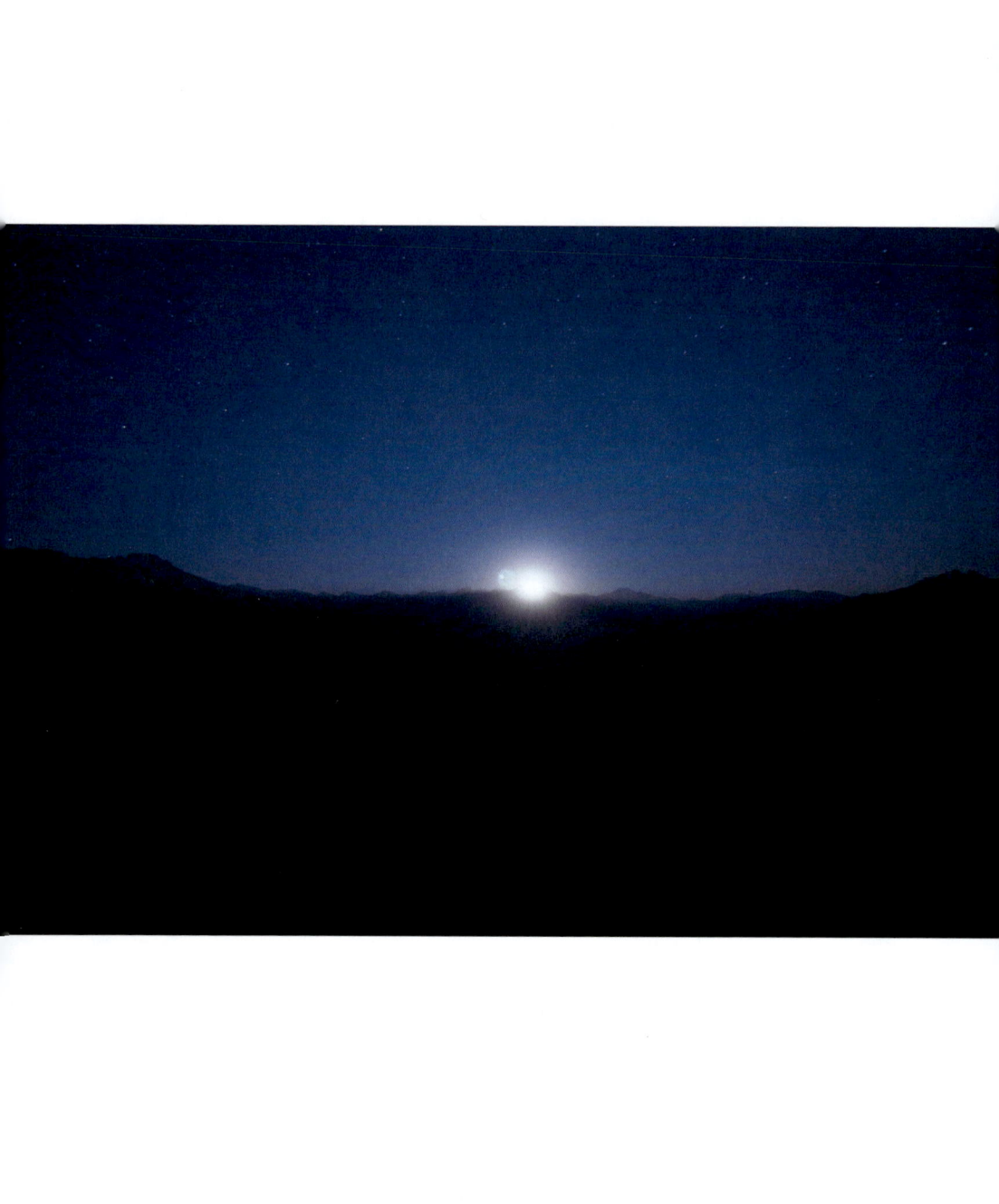

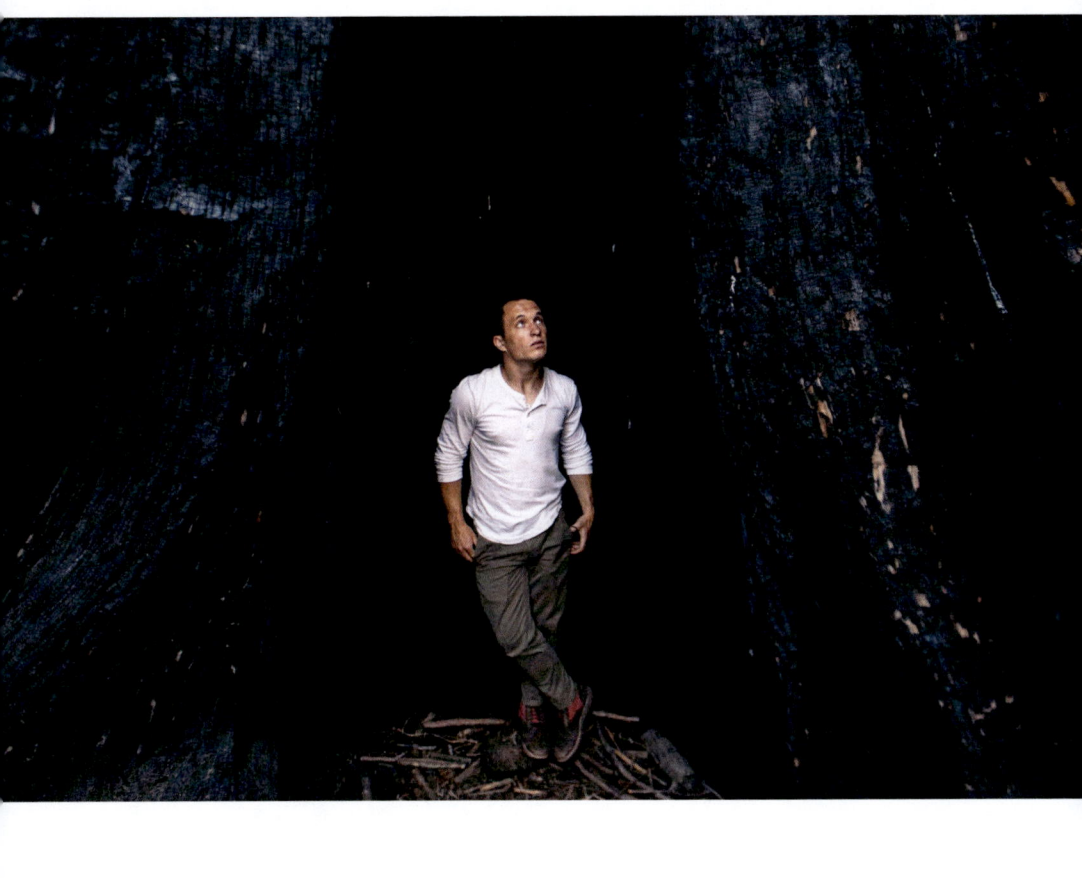

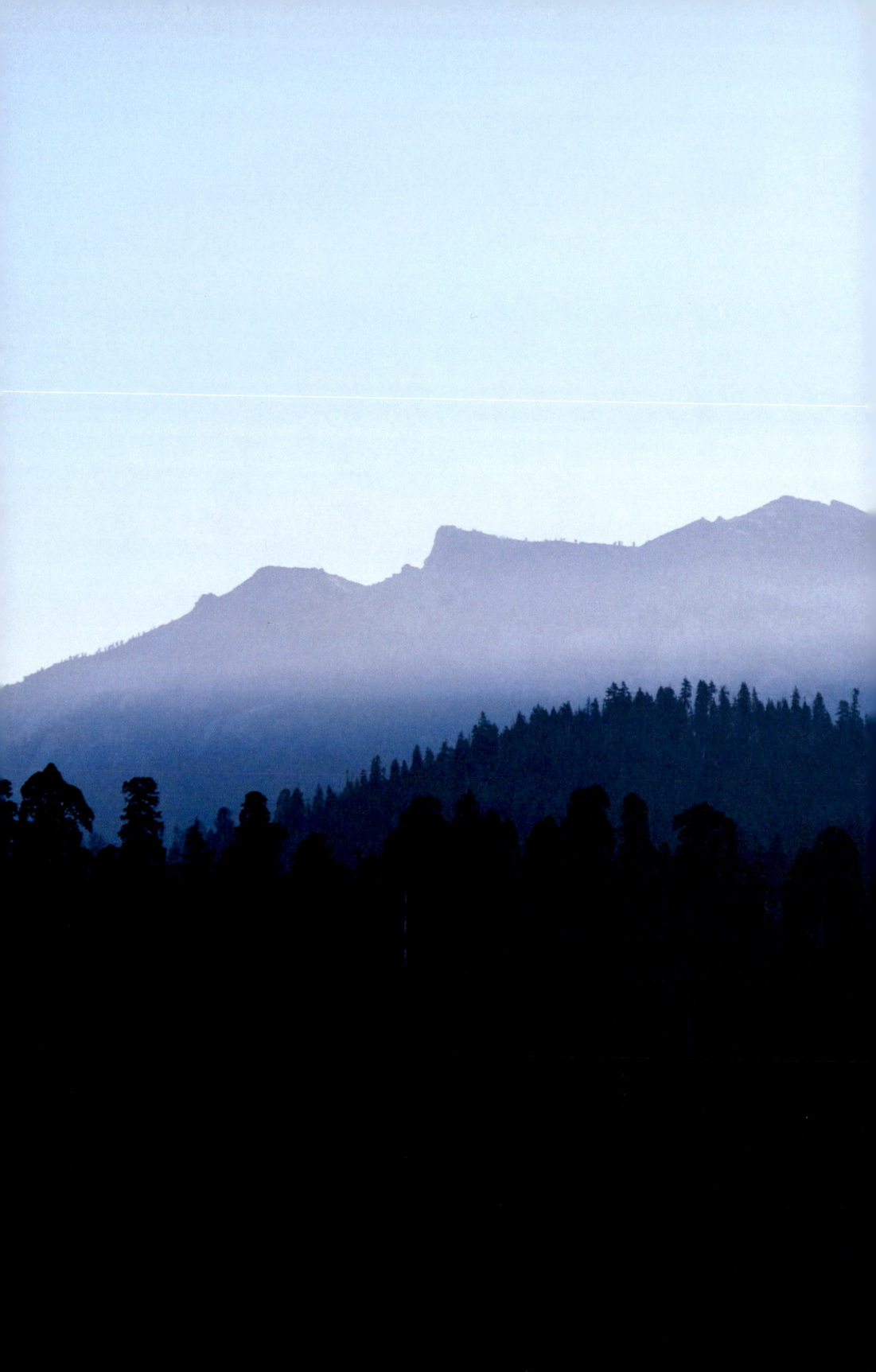

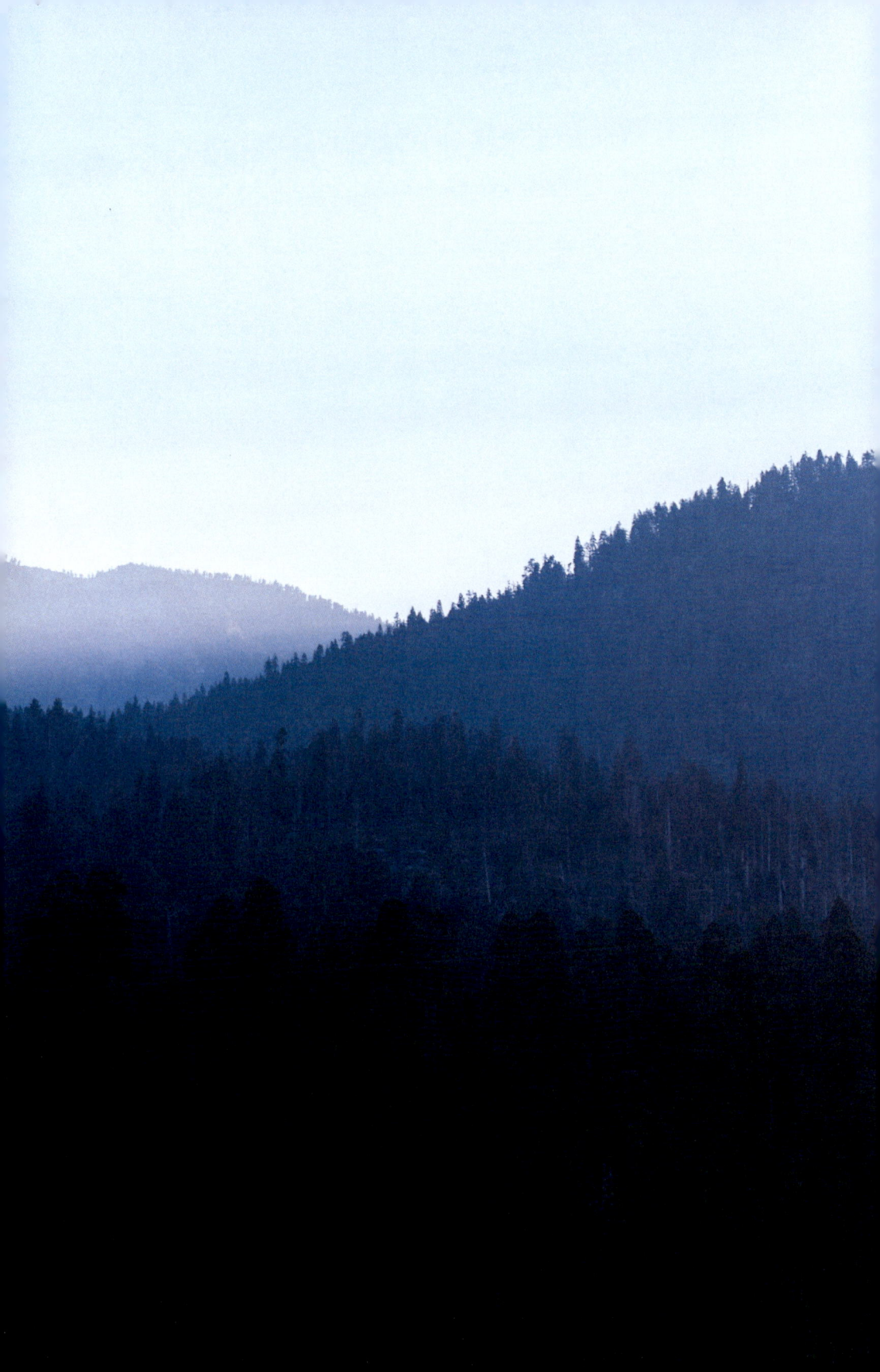

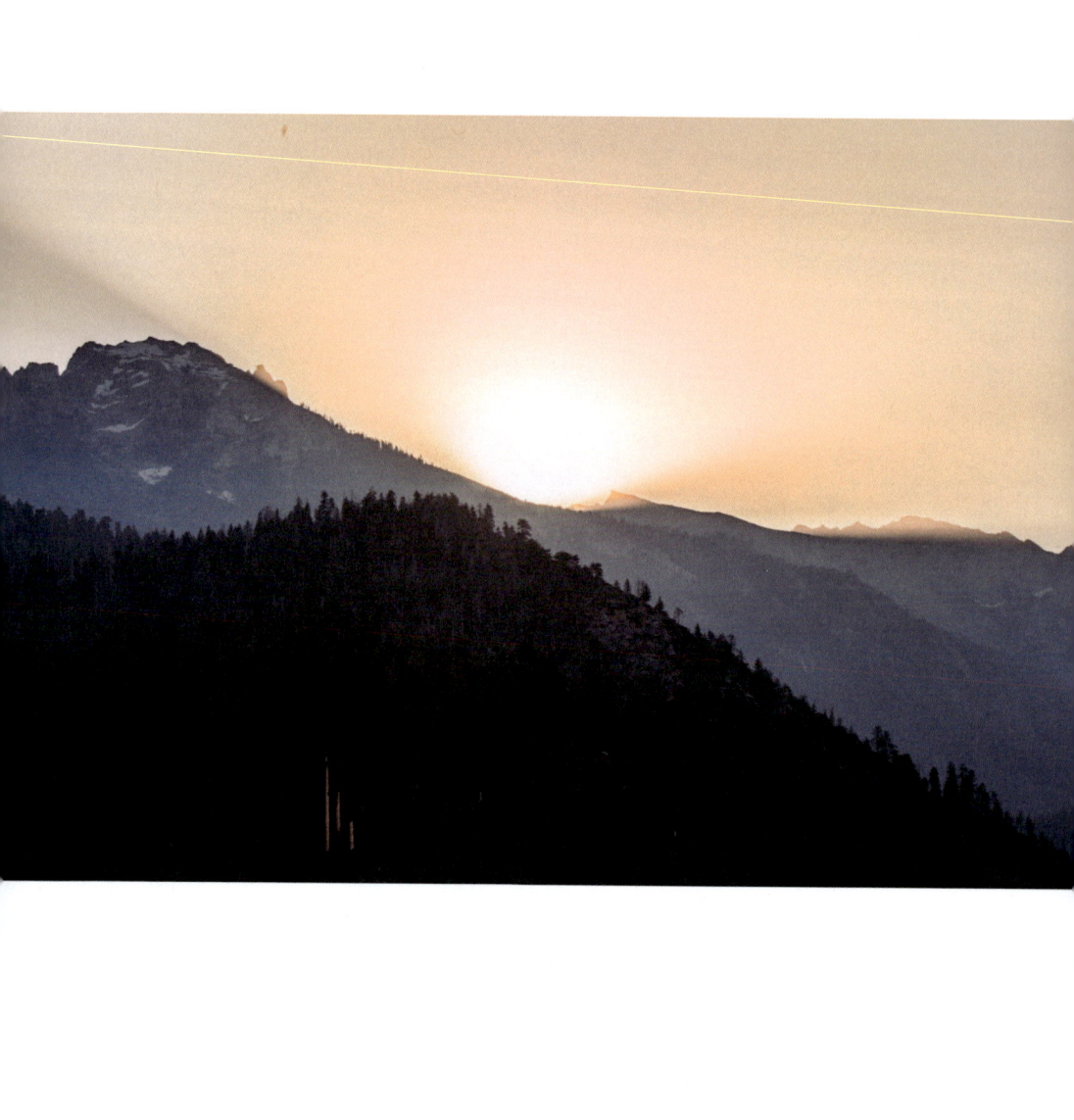

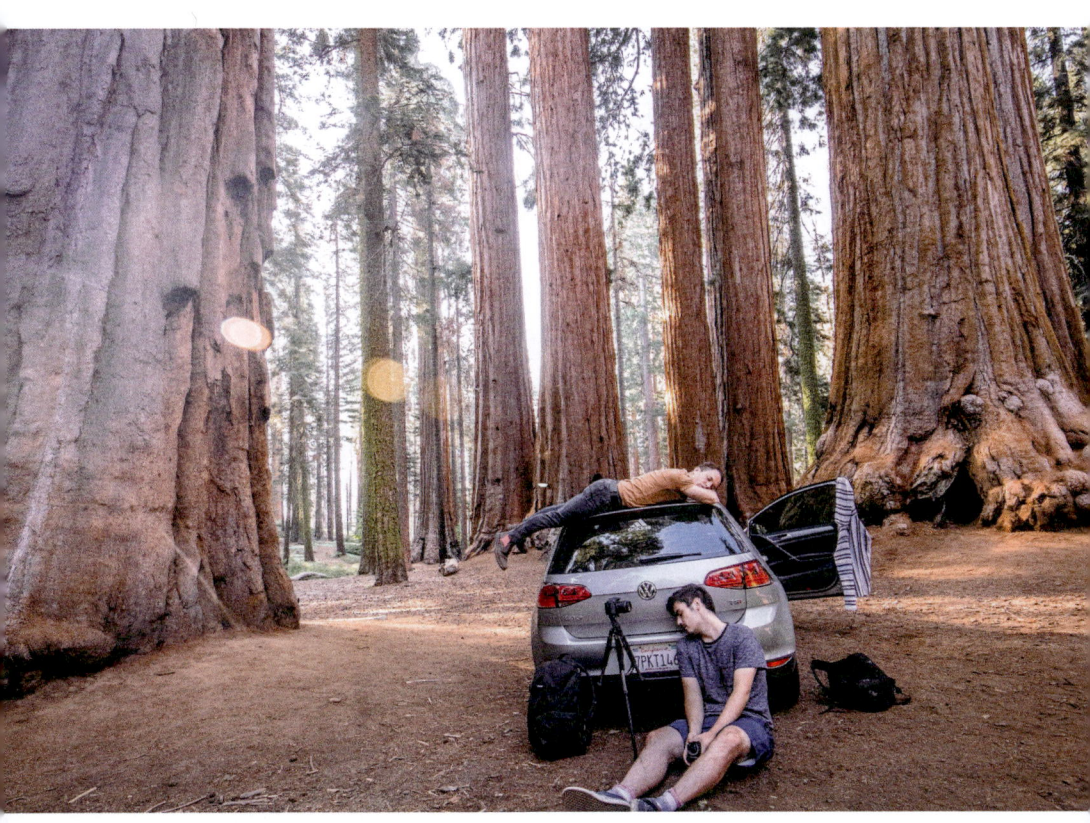

After ascending the four hundred granite steps of Moro Rock on eight separate occasions, we collapsed from exhaustion. But the hours spent trying to capture the magnificent sunset, clear starry-night sky, and the bright morning sun, were more then worth it.

Thank you for your time...

www.ingramcontent.com/pod-product-compliance
Lightning Source LLC
Chambersburg PA
CBRC092042170526
45172CB00007B/1251